Cameras on the Battlefield

Photos of War

by Matt White

Reading Consultant:
Timothy Rasinski, Ph.D.
Professor of Reading Education
Kent State University

Capstone Curriculum Publishing

Capstone Curriculum Publishing materials are published by Capstone Press, P.O. Box 669, 151 Good Counsel Drive, Mankato, Minnesota, 56002
http://www.capstone-press.com

Library of Congress Cataloging-in-Publication Data
White, Matt, 1955-
 Cameras on the battlefield: photos of war/by Matt White
 p. cm.
 Includes bibliographical references (p. 62) and index.
 Summary: Recounts the story of wartime photography, from the first use
of cameras on the battlefield through the war in Vietnam.
 ISBN 0-7368-4004-4 (Hardcover)—ISBN 0-7368-9504-3 (Paperback)
 1. War photography—United States—History—Juvenile literature.
2. United States—History, Military—Pictorial works—Juvenile literature.
[1. War photography—History.] I. Title.
TR820.6 .W49 2001
779'.9355—dc21

 2001003062

Created by Kent Publishing Services, Inc.
Designed by Signature Design Group, Inc.

Photo Credits:
Cover, P.J. Griffiths/Magnum Photo Inc.; pages 5, 7, 14, inset 17, 19, 36 right, 39, inset 47, Bettmann/Corbis; pages 8-9, Archivo Inconografico, S.A./Corbis; pages 10-11, The Granger Collection; page 17, Roger Fenton/Corbis; pages 20-21, Mathew Brady/Corbis; pages 22-23, Medford Historical Society Collection/Corbis; pages 24, 27, 29, 31, 32, The Imperial War Museum, London; page 36, Magnum Photos/Robert Capa; page 38, AP/Wide World Photos; pages 46-47, 49, Hulton-Deutsch Collection/Corbis; pages 53, 55, Tim Page/Corbis; page 51, P.J. Griffiths/Magnum Photos; page 51 inset, Magnum Photos; pages 56-57, David and Peter Turnley/Corbis; pages 58-59, Matt White, cameras supplied by Jessop's Classic Cameras, London; thanks to Jane Carmichael of The Imperial War Museum, London

Printed in the United States of America.

1 2 3 4 5 6 07 06 05 04 03 02

Table of Contents

Battle scene from the French and Indian War (1754-1763)

Before Photography

A man ducks for cover behind an overturned wagon. Overhead, cannonballs whiz by. The man is not a soldier. He is an artist. He is drawing pictures of the battle that rages around him. For these drawings, he is risking his life.

Pictures of War

For centuries, people have created pictures to show and report about war. People have used pictures to promote wars. People have used pictures to protest wars. Pictures have helped to begin wars and also to end them.

Paintings and drawings gave early images of war. Later came photography, then film and video.

rage: to be violent or noisy

Changing How We See War

Photography is the first medium to show war the way it really is. Real pictures have a powerful effect on how everyday people think about war. The camera gives war a human face.

Today we see television and newspaper reports of wars and other violence every day. News from anywhere in the world appears on our TV set just minutes after it happens. Within hours, newspapers carry pictures of these same events.

News before Photography

But what images of war did people see before photography? How did people get these images?

Before photography and TV, people "back home" saw only paintings or drawings of war. Magazines and newspapers paid artists to create these pictures. The images might not appear in print until weeks, maybe even months, after a battle.

medium: a means for sharing ideas or information with large numbers of people

War Artists before the Camera

Photography was invented in 1826. But it took many more years before cameras became popular reporting tools. Until that happened, many "battlefield artists" never went near a battlefield at all!

How did artists depict war before the camera? Let's look at three such artists to get an idea.

People hunger for news about war. Here New Yorkers read a large bulletin board for news about the Spanish-American War in 1898.

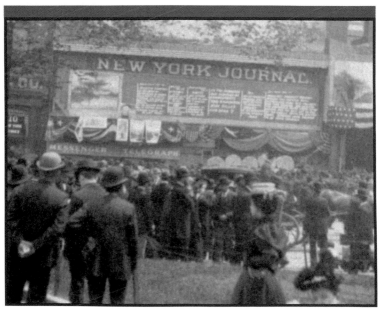

depict: to show or describe

Paolo Uccello (born 1397—died 1475)

Paolo Uccello (POW-lo oo-CHEL-oh) was a painter who lived in Italy. Powerful and rich people bought his paintings to decorate their rooms. They wanted beautiful paintings. So that's how he painted war scenes.

Uccello probably never even saw a battle. His job was not to depict history exactly as it is. It was to make beautiful paintings to please his wealthy customers.

Battle of San Romano: Bernadino della Ciarda is unhorsed, *by Paolo Uccello, 1454-57*

Constantin Guys (born 1802—died 1892)

Constantin Guys (con-STAN-tun GEEZ), unlike Uccello, saw war firsthand. This French artist took part in the Greek War of Independence (1822-1830) and the Crimean War (1853-1856).

Guys is known for his comic drawings of soldiers. While his words reported the battles, his pictures were humorous and like cartoons. Once again, the artist's pictures failed to show the horror of the battlefield.

Lady Elizabeth Southerden Butler
(born 1846—died 1933)

Several famous war paintings came from the brush of a high-society lady. Lady Elizabeth Southerden Butler traveled with her husband, General William Butler, when he went to war in Egypt and South Africa.

Lady Butler tried to paint things as they really are. But still she showed an idealized view. Her paintings show heroic British soldiers, with flags flying in the wind and horses charging.

idealized: cleaned-up and pretty rather than real

Charge of the Light Brigade (*1854*),
by Lady Elizabeth Southerden Butler

The Role of Pictures

Many early artists made war seem exciting
and glamorous. Governments sometimes
wanted this. If war looks horrible, it is hard
to get young men to fight.

Drawings and cartoons also can show the
enemy as monsters—someone not "like us."
Governments also sometimes wanted this.
If the enemy doesn't seem human, it is
easier to convince people to fight them.

glamorous: attractive and exciting

Bringing the Truth to Light

It is difficult to find a realistic battle account written before the 20th century. It is even more difficult to find a realistic illustration. This is why photography became so important in war reporting.

Joseph Niépce (JO-sef NEE-eps), a Frenchman, took the first successful photograph in 1826. To take this photograph, light was let in through a camera lens. The light shone onto a light-sensitive plate inside the camera. We say the plate was "exposed" to light. The light caused an image to appear on the plate. This first picture took eight hours to expose.

Some years later, another Frenchman, Louis Daguerre (loo-EE dah-GAIR), made an improved camera. Niépce and Daguerre became partners. But Niépce died a few years later, so Daguerre continued on his own. He brought down exposure times from eight hours to 20 minutes. He called his invention the "daguerrotype."

realistic: true; actual
sensitive: affected or changed by outside force

Making Progress

Before photography, people relied on drawings or paintings of battles to "see" what war was like. But these images often did not give a true or timely picture of war. Photography would change this.

Cameras didn't move to the battlefield right away, however. Equipment was heavy. It was difficult to develop pictures. But progress was being made. Also, new printing methods would soon allow newspapers to print photographs.

How do you think the public reacted to seeing more realistic images of war? Do you think war photographers faced any risks?

timely: coming at the right time or at a suitable time
develop: to treat exposed film or plates with chemicals in order to show an image

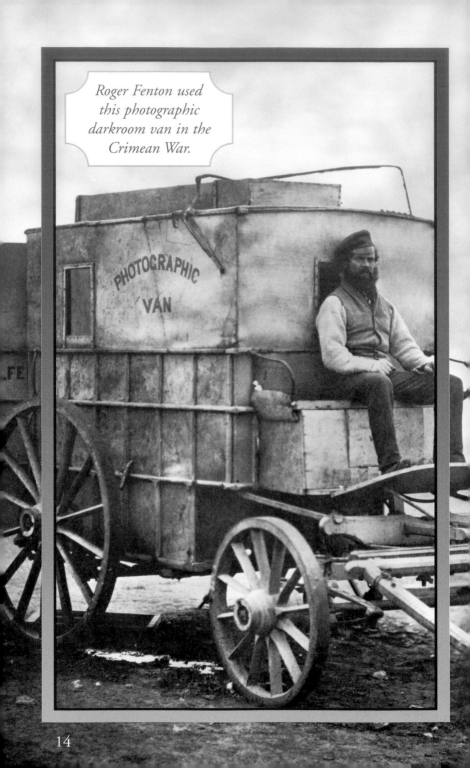

Roger Fenton used this photographic darkroom van in the Crimean War.

Photographers Go to War

A photographer looks out over a field of bodies. In the smoky light, he can barely make out the uniforms. He takes quiet aim with his camera. He does not want these men to be forgotten.

The First War Photographers

By the 1850s, cameras had become smaller and more portable. Now they were durable and much lighter to carry into battle.

The use of war photographs soon became popular with newspaper editors. Readers wanted to see what war was really like. This desire paved the way for the first war photographers. Roger Fenton and Mathew Brady were two of the first.

portable: easily carried
durable: lasting in spite of hard wear

Photography on the Battlefield

Armed with improved equipment, photographers went to capture real images of war. The first war photographer was Englishman Roger Fenton. He took his cameras to the Crimean War.

Even though cameras had improved, they still couldn't be used for action pictures. In the 1850s, everything had to be perfectly still during the shot. If anything moved, the picture would come out blurry. So Fenton took pictures of the landscapes after a battle.

Fenton's pictures were the first to bring the ugliness of the battlefield to people back home. But still his photographs didn't fully capture the grim truth of war.

Besides battlefield landscapes, Fenton also took portraits of generals and other officers in gallant poses. In return, officers helped Fenton travel to the battlefields.

landscape: a stretch of land
portrait: a drawing, painting, or photograph of a person
gallant: brave and noble

Roger Fenton (at right) took this photograph of General Sir George Brown and his staff during the Crimean War.

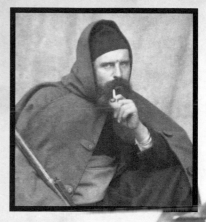

In the Line of Fire

Fenton used a horse-drawn van that held 36 cases of equipment. The van stored hundreds of glass plates to make the photographs. His van also was his darkroom. Once Fenton took a few pictures, he had to develop them quickly in the van.

One day, Fenton took a new batch of glass plates to be developed in his van. While developing the photographs, he heard gunshots and explosions outside. A battle had started.

Fenton could not stop developing the glass plates. If he did, the photos would be ruined. Continuing, he hoped he would be safe. Suddenly, a cannonball crashed through the van walls. It missed Fenton but let light into the room. The light ruined all the photographs he had taken.

glass plates: an early version of film mounted on glass instead of plastic

The Civil War

Roger Fenton was the first war photographer. But American Mathew Brady was the first photographer to depict the real death and destruction of war.

Photography had advanced since the Crimean War. Cameras were smaller and time exposures were shorter. Brady and his team of men turned their cameras on the Civil War (1861-1865). These brave men showed the world what war was really like.

Mathew Brady

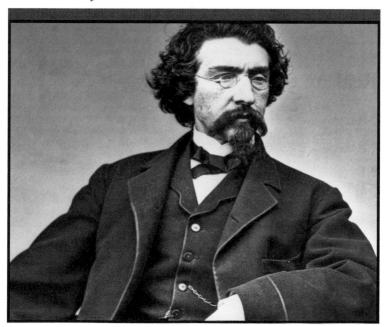

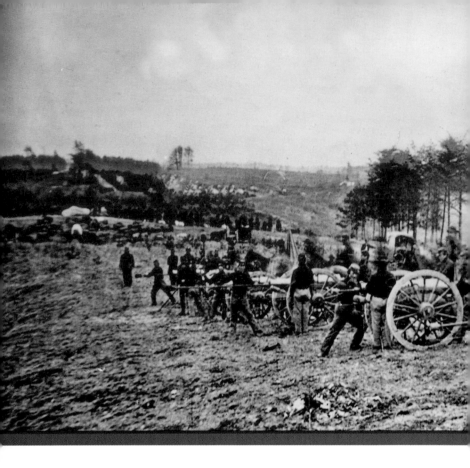

Real or Fake?

During the Civil War, photographs still took several minutes to expose. This was less time than before, but action photos still were difficult to take. Sometimes Brady set up fake "action" pictures. In fact, soldiers stood still for several minutes so Brady could take these pictures.

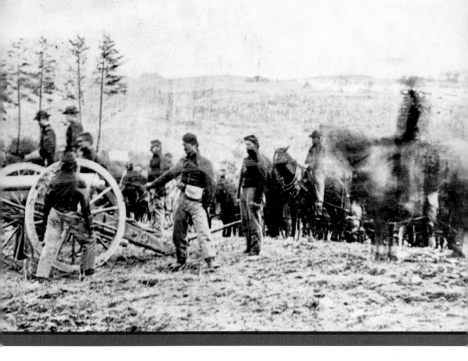

This first photo of the Union Army in combat was taken by Mathew Brady in 1861.

American Memories

Brady's pictures show the only images of war on U.S. soil. Many are shocking to look at. When the war ended, Brady tried to sell his pictures to make money. Although the government bought some, Brady died a poor man in 1896.

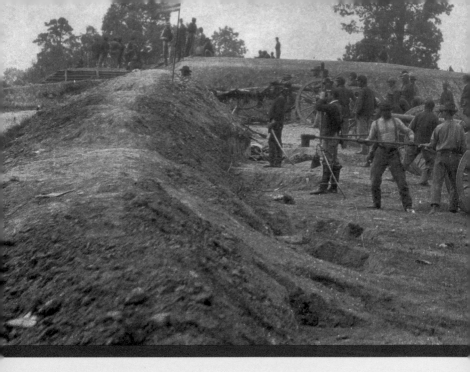

Cameras on the Battlefield

War photography was born in the mid-1800s. War photographers faced many challenges. Cameras and equipment were improving, but slowly. The process for developing film was primitive.

Early war photographers had to take time and risks to take battle pictures. This early equipment meant that "action" pictures had to be fake and posed.

primitive: very simple or crude

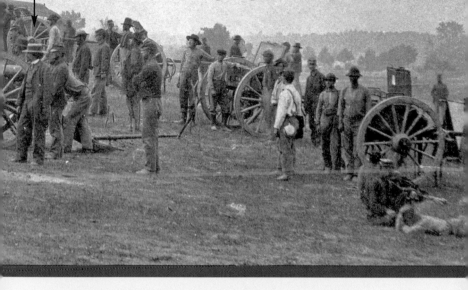

Brady, seen in the center, sets up an "action shot" in Petersburg, Virginia, in 1865.

By the turn of the century, however, photographers were reporting on many conflicts. When World War I (1914-1918) began, cameras on the battlefield were no longer rare.

What new challenges might the people behind the cameras face? What effect might still more realistic photos have on the public's reaction to war?

*Photographer
Ernest Brooks looks out
from a trench during
World War I.*

The First "Modern" War

Dozens of soldiers climb the ladders out of the trench. Guns and shells blaze overhead. Two hours later, only seven men return. All the others lay dead in no-man's-land. A photographer in the trench looks at his camera bag. Inside, undeveloped, are the last pictures of those men alive.

A War of Firsts

World War I was the first war in which the military used airplanes, submarines, torpedoes, and tanks.

Photographers, meanwhile, took pictures with new, advanced, portable cameras. In addition, cinematographers used motion picture cameras in war for the first time.

no-man's-land: the area of a battlefield that separates the enemies
cinematographer: a motion-picture cameraman

Free to Photograph

In World War I, photographers were free to go anywhere on the battlefield. Two of these photographers became well known—Frank Hurley and Ernest Brooks.

Frank Hurley

Frank Hurley gained experience and fame taking photographs of Sir Ernest Shackleton's Antarctic adventures. In 1917, Hurley was on duty photographing World War I.

Hurley used early flash equipment to take photographs inside dugouts and dressing stations. In his pictures, scared, wounded soldiers stare at the camera.

At other times, Hurley captured the beauty of northern France before years of battle scarred the landscape. His silhouette pictures of soldiers and countryside often appeared in magazines. These photos became particularly popular.

dugout: a shelter dug in the ground
dressing station: an area where wounded are treated
silhouette: a subject lit from behind; the subject appears dark against a light background.

Frank Hurley (at right) sets up his camera on an overturned tank in 1918.

Ernest Brooks

Ernest Brooks arrived at the front in northern France in March 1916. The biggest military event that year was the Battle of the Somme. On July 1, Brooks took a position in the front line at the moment the battle began.

First, Brooks photographed the troops as they gathered in the forward trenches. Then he photographed the huge mines exploded by the Allies just before the assault. Brooks' final pictures that day show the troops going over the top to attack.

Life in and out of the Trenches

Brooks and just one other photographer reported the entire British side of the war. It was tough. Battles occurred along a front hundreds of miles long. Photographers covered as much as they could. They were in demand both on and off the battlefield.

front: where the fighting is in a war
Allies: the nations that fought against Germany and its partners in World War I

Different types of photos needed different equipment and methods. One day these photographers captured grim soldiers in mud-filled trenches. The next day they aimed their cameras at well-dressed generals.

General Birdwood leaves headquarters in this photo taken in 1918 by Ernest Brooks.

Moving Pictures

Cinematographers joined the forces of those reporting on World War I. Their films gave the public yet another view of war.

In 1916, a British audience watched a newsreel about the war. This short news film showed the stark landscape of northern France, scarred by months of bombing.

The film also showed soldiers burying their dead. Wrapped in shrouds, dozens of corpses lay in a deep pit. Soldiers stood around the edge, their caps and helmets removed. A chaplain read from the Bible. It was clear this was a real burial.

The film shocked the public at home in Britain. For the first time, they saw that soldiers were dying in large numbers.

stark: bare and grim
shroud: a large piece of cloth in which a dead person is wrapped
chaplain: a minister, priest, or rabbi who serves in the armed forces

Bodies of dead soldiers await burial, 1918.

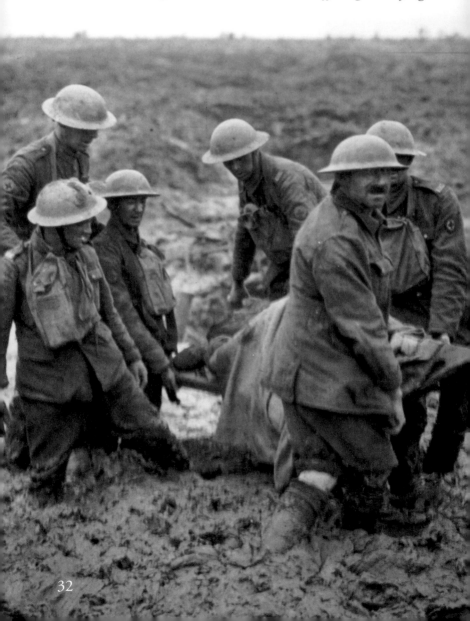

Photographs such as this one, taken in 1917, proved that soldiers were suffering and dying.

Even the Enemy Had Families

Photographers will always find it difficult to capture the essence of war. But in World War I, photographs did force the public to realize that their own boys were suffering and dying. Moreover, photographs showed that the enemy's dead were also somebody's sons, brothers, husbands, or fathers.

Now war had a face. Now people could see the real cost of war. In World War I, a large part of a generation was lost. They live on only in photographs.

Such a horrible record did not mean an end to war, however. In 20 years, the world would be at war again. What could make people willing to fight when photographs helped prove the cost was clearly so high?

essence: basic meaning

A Nazi soldier in Belgium, 1944

World War II

In France, a photographer dashes around a corner for cover from gunfire. There he finds two fellow photographers. He looks at their faces and sees the fear. All three have photographed terrible things that day. They shake hands. They are united in their mission to send pictures home.

New Conflicts

In the 1930s, new conflicts arose in Europe and Asia. Fascism and Nazism gained strength in Europe. Japan became a threat in Asia.

In 1939, World War II (1939-1945) broke out. Two new media would change public awareness during this war—news magazines and Hollywood films.

fascism: a system of government in which a dictator and a single party have complete control over a country
Nazism: the practices of the fascist political party that ruled Germany under Hitler from 1933 to 1945

Robert Capa

Many photographers during World War II also had covered the Spanish Civil War (1936-1939). Robert Capa was one of them. His photos from Spain showed a country tearing itself apart.

Capa took his most famous photo of that conflict for a news magazine in September 1936. Machine gun fire had pinned Capa and a Republican soldier in a trench. When the soldier climbed out of the trench, Capa took the photograph as the guns fired. The picture symbolizes the struggle against fascism in Spain.

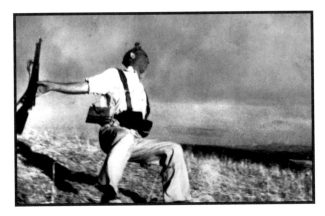

This 1936 Spanish Civil War photo is Robert Capa's (below) most famous.

Republican: a person who supported the elected government of Spain and opposed the fascists
symbolize: to represent or stand for

Courage and Tenderness

In World War II, Capa landed with U.S. troops in the June 6, 1944 D-Day invasion. On that day, Allied troops began the invasion of France. Sadly, all but eight of Capa's D-Day pictures were destroyed in a darkroom accident. Life magazine published the eight pictures. These photographs won Capa the Medal of Freedom award.

The brave Capa said of war photography: "If your pictures aren't good enough, you aren't close enough."

War affected Capa deeply. At the end of World War II, he said, "I hope to stay unemployed as a war photographer till the end of my life."

Much as he hated war, Capa continued to put himself in danger. In 1954, while on an assignment for Life magazine in Indochina, he stepped on a land mine and was killed.

Allied troops: soldiers from the nations joined together to fight Germany, Italy, and Japan

Hollywood Goes to War

When the United States entered World War II, Hollywood film directors went, too. Director William Wyler made a short film in 1943 about life on board a U.S. bomber plane. "The *Memphis Belle*" is a documentary about a B-17 bomber on a mission over Europe.

The film shows German fighter planes shooting at the *Memphis Belle*. It is badly damaged. Some crew members are seriously injured. The *Memphis Belle* limps back to its air base in England. When the crew jumps out of the plane, one of them kisses the ground, he is so happy to be alive. Films like this did a lot to boost morale back home in America.

Memphis Belle

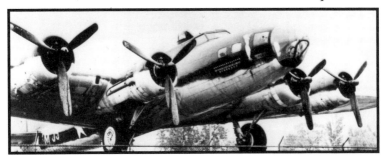

documentary: a dramatic story based mainly on facts
morale: mental and emotional well-being

George Stevens

Another Hollywood director, George Stevens, followed the U.S. Army during and after the D-Day landing.

Stevens took still and movie cameras with him. On color movie film, Stevens shot the U.S. and British armies as they pushed the Germans back through war-torn France and Belgium. He also showed joyful scenes of people in Paris as they celebrated their freedom from the Nazis.

Troops wade to shore in Normandy, 1944.

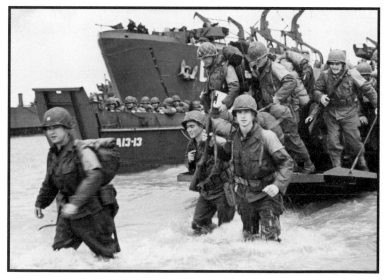

Horror on Film

Englishman George Rodger followed the Allied advance across Germany to a concentration camp at Belsen. What he saw there deeply affected him.

Thousands lay dead. Horrified, Rodger took photographs of the piles of bodies. He treated them as he would a landscape or anything else. He allowed the photographs to speak for themselves.

He said later: "...I swore I would never, never take another war picture and I didn't. That was the end."

In 1945, Bernard Montgomery, commander of the British forces, accepted the surrender of Germany at Lüneburg Heath, Germany. Rodger was one of only two photographers to record the event.

concentration camp: a camp where people are held against their will, often in harsh conditions

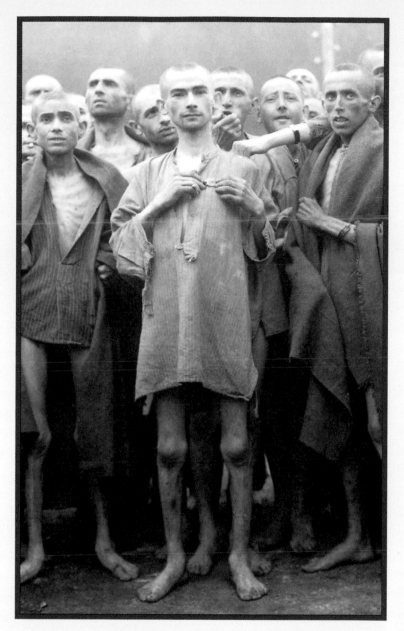

Photographers captured on film the horrible truth about Nazi concentration camps.

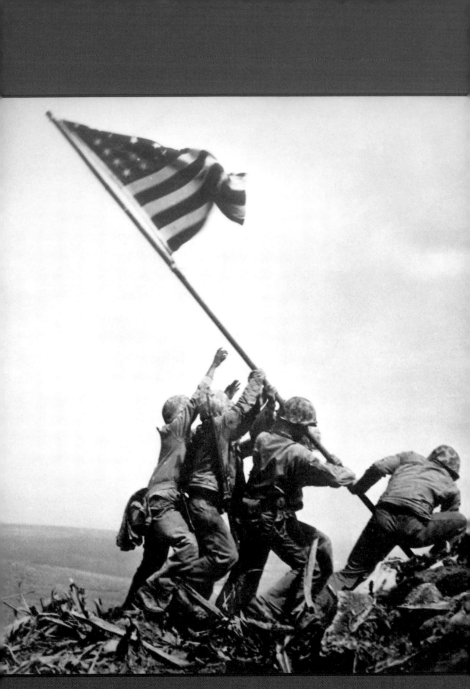

One famous World War II photo is of these U.S. Marines as th[ey]
raise the flag on top of Mount Suribachi, Iwo Jima, in 194[5]

Playing a Larger Role

The popularity of news magazines and films soared during World War II. Both did more to show people the true face of war than other media had in the past.

The demand for news magazines gave photography a much larger role in World War II. Photographers took pictures of horrible and also heroic scenes to tell the war story back home. For the first time, many of these pictures were in color. News magazines became a new and very visual way of reporting the war.

Hollywood directors also recorded and reported events from the war. In future years, motion picture recordings, and in particular television and video, would continue to change war reporting. What sorts of changes do you expect will occur?

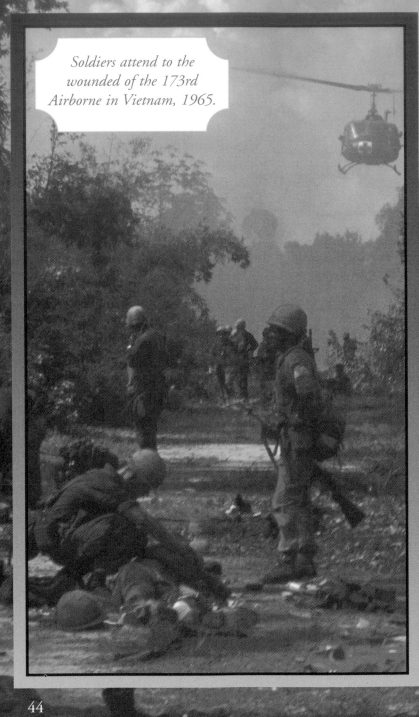

Soldiers attend to the wounded of the 173rd Airborne in Vietnam, 1965.

Korea and Vietnam

In 1969, a picture in a magazine shows a woman standing over an open coffin. The coffin holds the body of a dead soldier, her son. Tears stain the woman's suffering face. All over the United States, parents look at the photo. The young man could easily be their son.

War Comes to TV

During the Korean War (1950-1953), the U.S. government heavily censored war reports. But by the Vietnam War (1954-1975), the government had less control over reporting.

By the 1960s, television brought daily live reports of the war in Vietnam. Some people thought that TV was replacing the printed photograph. However, still photography would help change the course of this war.

censor: to remove anything thought not right for people to see or hear

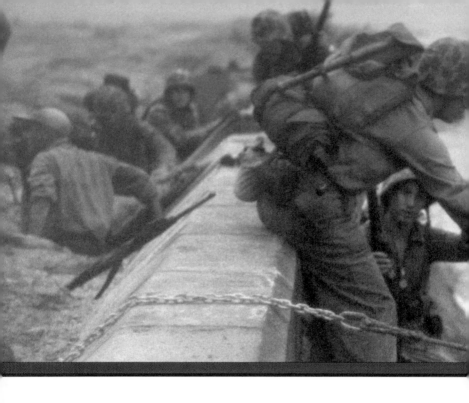

Modern Cameras Get the Picture

Modern photo equipment proved its usefulness during the Korean War. Without it, Bert Hardy could never have taken the photos at Inchon Beach, Korea.

Hardy landed with U.S. troops at Inchon Beach on September 15, 1950. It was late evening, and the light was fading fast. Hardy had a new Leica camera with fast film.

fast film: extra-sensitive film for shooting in low light

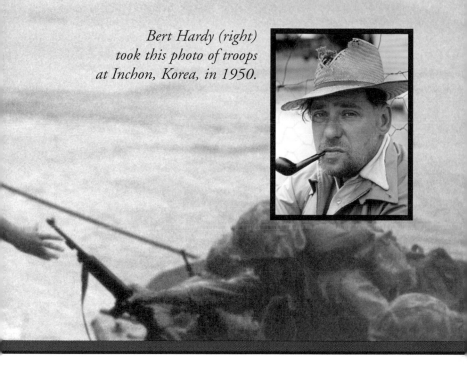

Bert Hardy (right) took this photo of troops at Inchon, Korea, in 1950.

Hardy climbed over a high wall into what he thought was enemy gunfire. He photographed the troops following him. He was the only photographer to get pictures of this landing.

Later, an officer told Hardy they had landed on the wrong beach. The gunfire was from their own side. But the Leica and the fast film gave Hardy pictures of troops landing—the only ones taken of that event.

Matters of Life and Death

Picture Post magazine published many of Hardy's photographs of the Korean War. One such photo story led to the firing of the Post editor.

In the Korean War, the United States and Great Britain supported South Korea. The South Koreans had captured a group of political prisoners and tied them together. Hardy took pictures of this group.

Hardy and journalist James Cameron feared the South Koreans would execute these prisoners without a trial. The two journalists protested, but the prisoners were later executed. At Picture Post, editor Tom Hopkinson tried to publish the pictures of the captured prisoners.

The magazine owner stopped the printing presses and withdrew the pictures. Hopkinson put the article back in again the next week. Again the story was removed. This time Hopkinson was fired.

political prisoner: a person in prison because of his or her beliefs
execute: to put to death
journalist: a person who reports the news

Photo of North Korean prisoners taken by Bert Hardy, 1950

The Vietnam War

During the Vietnam War, photographers could take photos quite freely. This did not always please the U.S. government.

Indeed, some photojournalists came to object to the U.S. role in Vietnam. Philip Jones Griffiths was one such photographer.

Griffiths claimed that the war was destroying a Vietnamese society that could teach the United States a great deal. He felt the Vietnam War was destroying the youth of both the United States and Vietnam.

Griffiths said that he used his camera to comment on the truth of the Vietnam War. He said, "What made me addicted to the place was the desire to find out what was really going on, after peeling away layers and layers of untruths."

Magnum

Griffiths was a member of Magnum photo agency. Magnum was started in 1947 by Robert Capa, photographer Henri Cartier-Bresson, and others. By the 1960s, Magnum was a well-respected organization.

However, Magnum's photographers were against the Vietnam War. This made them unpopular with the U.S. government.

U.S. soldiers offer water to a wounded Vietcong in this 1968 photo by P.J. Griffiths (at right).

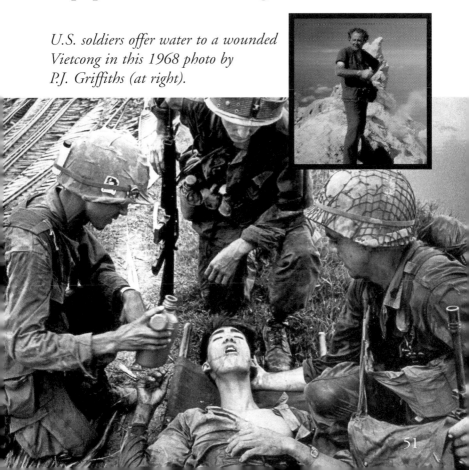

51

"It Made Me Ashamed"

Griffiths wasn't the only photographer from Magnum to cover the Vietnam War. Don McCullin covered the war during 1968-69.

Experienced photographers like McCullin knew when not to take photographs. McCullin recalled the public execution of a street bomber in Saigon.

"It shouldn't have been a public display of theatrical execution. It should be done in private. So I kind of walked away. I heard a journalist saying 'Great stuff! Did you get it?' It made me ashamed."

Dangerous Job

Another photographer, Tim Page, was taking photos for Time magazine in Vietnam in 1969. An anti-tank mine exploded near him, sending shrapnel into the back of his skull. He survived. Not all photographers were so "lucky."

theatrical: dramatic; showy
shrapnel: metal balls or fragments scattered by an exploding shell

The War Ends

Photographs had a great influence on how people viewed the Vietnam War. In part because of photographs, waves of protest rippled around the world over the war. A powerful anti-war movement grew. The war finally ended in 1975.

Tim Page took this photo in Vietnam in 1968.

Pictures that Do Not Fade

Many people thought that TV and video film would replace still photographs for news reporting. For a while, TV could send images around the world faster than ordinary photography. Today, however, photographs can be sent just as quickly over the Internet.

A still image has great power. Still photographs convey the heart of a moment in a way that TV, movies, and videos cannot.

Brave photographers, like soldiers, have risked their lives on many battlefields. Their work has changed the way our world looks at war. Many of their images haunt us still.

Tim Page took this photo of U.S. Airborne troops after a battle in Vietnam in 1966.

haunt: to stay on one's mind

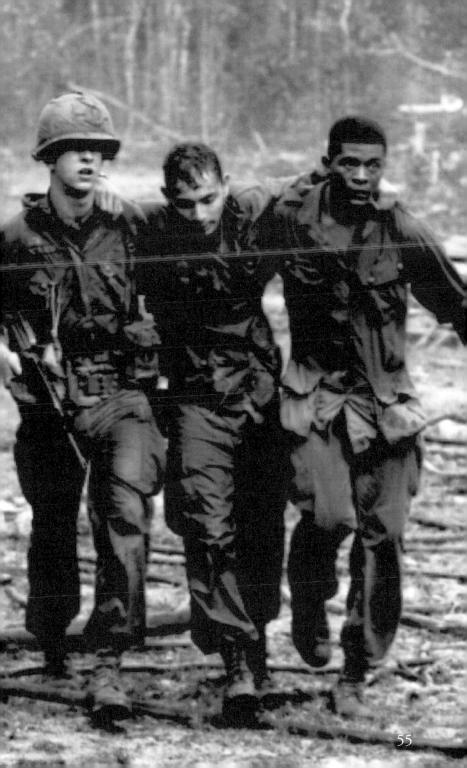

Epilogue

Censorship

Cameras arrived on the battlefield about 150 years ago. Since that time, the role of the war photographer has constantly changed. By the time of Vietnam, photography had become a powerful tool. In fact, photos shot in that conflict helped lead the United States to review its role in the war.

Since the war in Vietnam, censorship has returned to war reporting and photography. During the Gulf War (1990-1991), the U.S. and Iraqi governments heavily controlled what the public heard and saw.

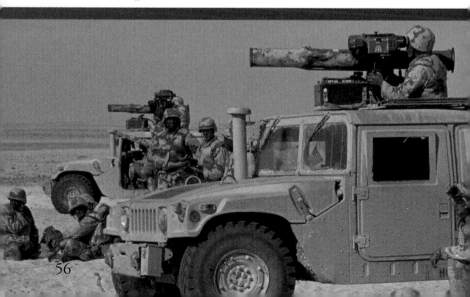

New Technology

Technology has also played an important part in changing the war photographer's role. Better equipment has made it easy to capture real scenes quickly. Now the Internet can send these images around the world almost instantly.

What will war photography look like in the future? How will technology affect it? Who will decide what photos a photographer can take? Who will decide what photos are published?

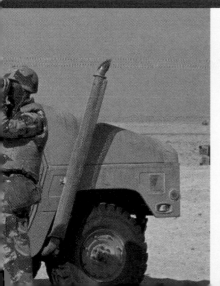

American soldiers in Saudi Arabia during the Gulf War, 1990

Cameras for the Job

Cameras are a war photographer's most important tool. Here are some cameras that have been used on battlefields over the years.

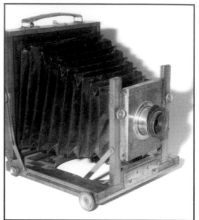

The Lancaster, 1850-1900

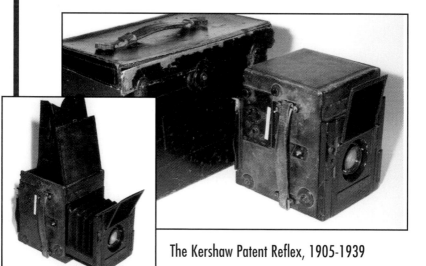

The Kershaw Patent Reflex, 1905-1939

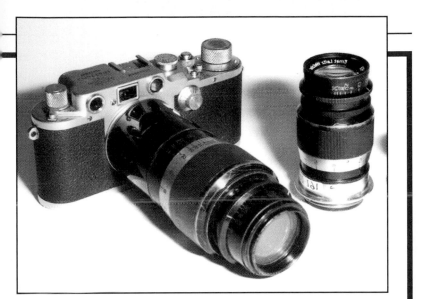

The Leica IIIc, 1940 model

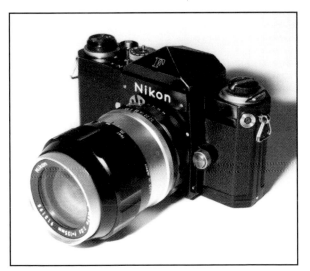

Nikon F, 1973 model

Glossary

Allied troops: soldiers from the nations joined together to fight Germany, Italy, and Japan

Allies: the nations that fought against Germany and its partners in World War I

censor: to remove anything thought not right for people to see or hear

chaplain: a minister, priest, or rabbi who serves in the armed forces

cinematographer: a motion-picture cameraman

concentration camp: a camp where people are held against their will, often in harsh conditions

depict: to show or describe

develop: to treat exposed film or plates with chemicals in order to show an image

documentary: a dramatic story based mainly on facts

dressing station: an area where wounded are treated

dugout: a shelter dug in the ground

durable: lasting in spite of hard wear

essence: basic meaning

execute: to put to death

fascism: a system of government in which a dictator and a single party have complete control over a country

fast film: extra-sensitive film for shooting in low light

front: where the fighting is in a war

gallant: brave and noble

glamorous: attractive and exciting

glass plates: an early version of film mounted on glass instead of plastic

haunt: to stay on one's mind

idealized: cleaned-up and pretty rather than real

journalist: a person who reports the news

landscape: a stretch of land

medium: a means for sharing ideas or information with large numbers of people

morale: mental and emotional well-being

Nazism: the practices of the fascist political party that ruled Germany under Hitler from 1933 to 1945

no-man's-land: the area of a battlefield that separates the enemies

political prisoner: a person in prison because of his or her beliefs

portable: easily carried

portrait: a drawing, painting, or photograph of a person

primitive: very simple or crude

rage: to be violent or noisy

realistic: true; actual

Republican: a person who supported the elected government of Spain and opposed the fascists

sensitive: affected or changed by outside force

shrapnel: metal balls or fragments scattered by an exploding shell

shroud: a large piece of cloth in which a dead person is wrapped

silhouette: a subject lit from behind; the subject appears dark against a light background.

stark: bare and grim

symbolize: to represent or stand for

theatrical: dramatic; showy

timely: coming at the right time or at a suitable time

Bibliography

Greenberg, Keith Elliot. *Photojournalist: In the Middle of Disaster.* Risky Business. Woodbridge, Conn.: Blackbirch Press, 1996.

Life: Our Century in Pictures for Young People. Edited by Richard B. Stolley; Adapted by Amy E. Sklansky. Boston: Little, Brown and Co., 2000.

Sullivan, George. *Portraits of War: Civil War Photographers and Their Work.* Brookfield, Conn.: Twenty-First Century Books, 1998.

Van Steenwyk, Elizabeth. *Mathew Brady: Civil War Photographer.* Danbury, Conn.: Franklin Watts, 1997.

Useful Addresses

George Eastman House International Museum of Photography and Film
900 East Avenue
Rochester, NY 14607

Imperial War Museum, Photograph Archive
All Saints Annexe
Austral Street
London SE11 4SL
England

National Archives & Records Administration
700 Pennsylvania Ave, NW
Washington, DC 20408
1-800-234-8861

Internet Sites

Civil War Photography Center
http://www.civilwarphotography.com/

Photography
http://www.comptons.com/encyclopedia/ARTICLES/0125/01439488_A.html#P1

Pictures of World War II
http://www.nara.gov/nara/nn/nns/ww2photo.html

Index